Did you know that word-for-word, professional audio support for this book is available at Book Buddy?

GoReader™ powered by Book Buddy is pre-loaded with word-for-word audio support to build strong readers and achieve Common Core standards.

The corresponding GoReader™ for this book can be found at: http://bookbuddyaudio.com

Or send an email to: info@bookbuddyaudio.com

URBAN ENTREPRENEUR

STREET ART

LAKE PARK HIGH SCHOOL
ROSELLE, IL 60172

Urban Entrepreneur: Street Art

Scobre Educational
2255 Calle Clara
La Jolla, CA 92037

Scobre Operations & Administration
42982 Osgood Road
Fremont, CA 94539

www.scobre.com
info@scobre.com

Scobre Educational publications may be purchased for
educational, business, or sales promotional use.

Cover and layout design by Jana Ramsay
Copyedited by Susan Sylvia, Renae Reed
Some photos by Getty Images

ISBN: 978-1-61570-952-6 (E-Book)
ISBN: 978-1-61570-888-8 (Hard Cover)
ISBN: 978-1-61570-874-1 (Soft Cover)

TABLE OF CONTENTS

Chapter 1
Street Art Defined and the Rise of Banksy

"What is art?" From Paris to London and from Los Angeles to New York, it is a way of decorating the world, much like fashion. Just walk down your street and you will see many examples of art. Advertisers understand the importance of art and so

People say Banksy's work is influenced by Blek le Rat, an artist from Paris who did stencil street art in the 1980s. But Banksy says he is influenced by the artist known as 3D from the musical group Massive Attack.

do politicians. It is the way to get messages across. Street artists understand this reality and use this freedom to send their own message.

Look around your city. You may see large blank walls on the sides of buildings that have not been decorated. Many times you will see areas like this that have been covered by art. This work is done by a street artist.

What do people use to make street art?

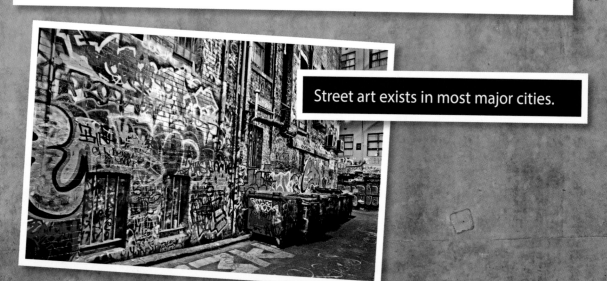

Street art exists in most major cities.

Spray paint is the most commonly used medium of of street art.

Stickers, stencils, posters, video projection, flash mobbing, work with tile, murals, woodworking, and often just straight-up spray paint!

In other industries, you can clearly see the heroes. Rap has Jay-Z. Basketball has LeBron James. Country music has Taylor Swift.

Some of the names of the top street artists are not well known. Not like rappers

and actors and fashion designers. Some of the more famous street artists are Shepard Fairey, WK Interact, KAWS, Paul Insect, Swoon, Twist, Neck Face, FAILE, Space Invader, and, the most famous artist, Banksy.

Banksy is an artist from London who has a unique style that has contributed to his fame. When you look at his works, painted on the sidewalk or the side of a building, they almost look three dimensional.

Banksy often paints on the side of a building, with a stencil technique. This Banksy creation is titled "Crayon House Foreclosure."

He uses a stencil technique. He did graffiti first, but he was slow, so he began to prepare his pictures in great detail in his studio. He would then set out to post them around the city.

Part of the thing that makes people talk about Banksy is that they do not know his true identity. Street art is the kind of thing where this is possible, since he can post his work without anyone seeing him. Some were critical of his work, saying that it was not real art. But he was able to eventually get his artwork into actual shows at galleries, where it sold for high price tags ($50,000, $100,000, and

Banksy's movie, "Exit Through the Gift Shop," was shown at the Sundance Film Festival. The film was nominated for the Academy Award for Best Documentary Feature.

$400,000). He even made a movie, "Exit Through the Gift Shop," which told his story.

Banksy was able to get attention because he had talent. People pay attention to great talent. But talent is something that is built over time. Banksy worked on his style and then decided to get his work out to the masses in order to achieve success. What is success? Fancy awards? Making lots of money? This is not really

what an artist is shooting for—but they can achieve it sometimes. Banksy was nominated for an Oscar for his movie, and according to some estimates, Banksy is worth $20 million!

Banksy's work is a great example of how street art changes the way people see the world. He is also an example of art as an industry. If you want to be the next Banksy, you must have the talent to create art. You must understand that there is a business side to it, too. If you have the right attitude, it can be very helpful to your career as an artist.

When becoming a street artist, it

is about just doing it. It is also about finding your own vision, and your own way of expressing yourself. When that is achieved, the street artist can create beautiful works of art—for the benefit of society!

People do not know Banksy's true identity.

Chapter 2
KAWS, Artist and Entrepreneur

Have you ever heard anyone say that art is not useful? That it's not a good way to earn money and pay the bills? Well, feel free to tell the tale of KAWS to them. KAWS' experience is inspirational and could change their minds.

Starting young is often a key for entrepreneurs. KAWS started his amazing journey in high school. He was born Brian Donnelly and he grew up in New Jersey. He did graffiti and focused on what was interesting to him. He loved

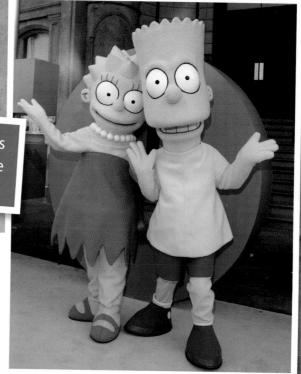

Comic book characters like the Simpsons were an inspiration to KAWS.

cartoons, such as the Smurfs, Mickey Mouse, the Simpsons, SpongeBob SquarePants, and "Star Wars." He then went on to college, where he studied fine art and got his degree.

After college, he got a job making cartoons and worked at Disney and on shows like "101 Dalmatians." He

continued to do street art, putting the cartoon themes into his creations. The result stood out to people as different, and it got lots of attention! His technique was to use images that are repeated often, in an effort to reach as many people as possible, even people who speak a different language.

As his career moved along, he started to become a businessman,

in a way. By walking the line between a cartoonist and a street artist, he carved out a place in the art world that was completely his own. He was always a hard worker, but maybe the most striking thing about him is that he created his own style and found his own voice. In a sea of graffiti art, his stuff stood out. That is the key.

In his street art, he would use the original advertisement and spin it in his own style. He never got in any legal trouble that wasn't controllable, and as a result, businesses liked what they

saw him do. As his name began to be well-known, his work was wanted by many people. In the clothing business, he did design work for Vans and Nike. In the advertising world, he created a bottle design for Dos Equis.

Then, a great thing happened. He was welcomed by the hip hop community! Pharrell Williams, the famous singer and producer, became a supporter and worked with him on BAPE clothing. In addition, he was asked by Kanye West to design the cover art for his album *808s & Heartbreak*, which brought his work to millions of people!

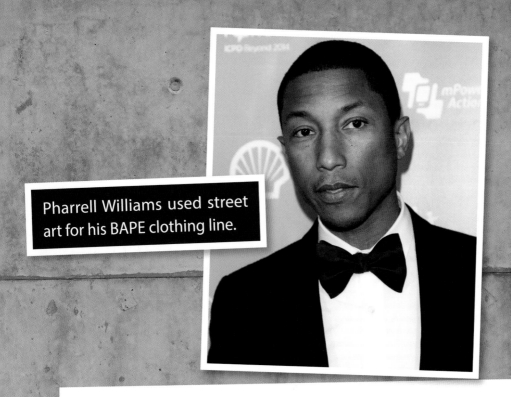

Another area where he clicked was the toy world. He worked with a company in Japan. He did limited edition toys, too, that sold well. One of his most popular was a character called "Companion." This character became so popular that in 2012, it

was used in the Macy's Thanksgiving Day Parade in New York City.

So the work of KAWS could show up in front of your eyes at any time. You might have seen his art on TV in the Thanksgiving Day Parade or on the cover of a Kanye West album! He started with

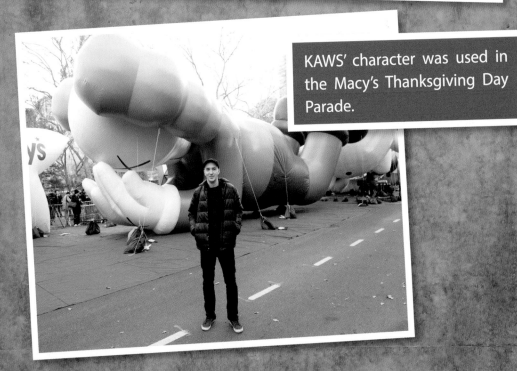

KAWS' character was used in the Macy's Thanksgiving Day Parade.

KAWS made a toy called "Companion." This toy resembled Mickey Mouse. It was different in that it had X's for eyes. He sold this toy through his website and it became a runaway success in sales.

an idea and then figured a way to get it out to the rest of the world. Now his images are everywhere. He shows one of the keys to being an entrepreneur: coming up with something that no one else has thought of and then finding a demand for it. As well as having some luck, some drive, and being able to do the good old-fashioned hard work.

Chapter 3
Street Art on the Internet

Art is on the internet everywhere. Sometimes, people only watch a video of a piece of art when it shows up on the internet. That is how it catches on. One example of this is art by Jorge Rodríguez-Gerada. Some call him a street art legend.

He was invited to Amsterdam, where he made a large picture of part of a woman's face, and it mostly showed her eyes. It was the size of two football fields. The picture was used for something bigger:

Rodriguez-Gerada decided that because of Google Earth and Google Maps he would work on a project that was large enough to be seen from space. The name of his first project of this size was "Expectation."

a message about how humans should treat each other better. The look in this person's eyes was supposed to make people think about people who were not being treated well in that part of the world.

It was created in one week. Eighty people volunteered. This is part of something called "culture jamming." It is something that a large amount of people are involved with in America. The size of this project could only be really seen

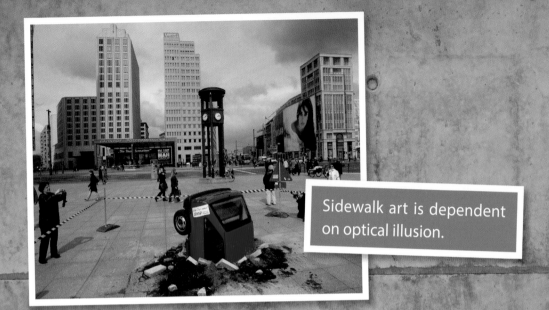

when videos were posted online so that a person could get an overhead view.

The internet can be a competitive place for art. Everyone is looking for the most views. YouTube shows many situations where street art is on display. For instance, one by Edgar Mueller has nearly seven million views. It is the

making of a piece called "The Crevasse" and it is an amazing sight. Many people look at this artwork the way they would look at the work of a magician.

Kurt Wenner and Julian Beever are other artists who have many famous videos on YouTube with millions of views. They work in a way that plays with how things look from different angles. Their

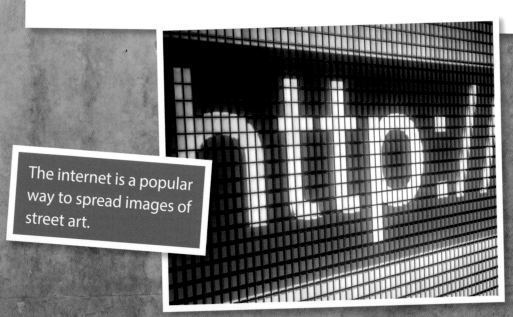

The internet is a popular way to spread images of street art.

videos are amazing and make you want to forward them to a friend so they can see for themselves. Many of these are paid for by businesses, and one features a Coca-Cola bottle, while another features a Sony computer.

One key to art on the internet is that it must be fun to look at. It is a place where street art is okay. On a certain street, at certain times, a person can create something that can be filmed and shown to millions of people around the world. They also often need to do some work with their

video clip so that it becomes a bit of a story that unfolds, like a magic trick, with an amazing art piece at the end. When looking at the works of Jorge Rodríguez-Gerada, Edgar Mueller, Julian Beever, or Kurt Wenner, you are seeing something that caught the eye of millions of people.

Some people ask, why stage such a large art project? Well, sometimes the size of it is what actually gains the attention of people. These large projects, involving large amounts of people, catch

Kurt Wenner worked at NASA before he became a sidewalk artist. At NASA he was an illustrator who created paintings of upcoming space operations and landscapes of distant planets.

the attention of people because they recognize how much hard work went into it. So the guys who get lots of hits on YouTube are doing something that fills a need. While it may not be clear what the use is, it is something that makes you want to keep watching.

So if you look at a picture or a painting that takes up the size of a building, or a video of many people creating a project just for the sake of art, understand that

Julian Beever featured photos of his art in a book called *Pavement Chalk Artist*. It shows many works of his art that have been made in many locations throughout the world.

a lot of sweat and thought goes into those projects. The artists not only have the idea but they also really care to see it through.

Street art is designed to catch the eye of people who are passing by.

At this point it should be clear about the world of street art: you will constantly be surprised by what entrepreneurs can do. Sometimes what seems like a small action can create a ripple effect that stretches far and wide. In the case of Shepard Fairey, he was

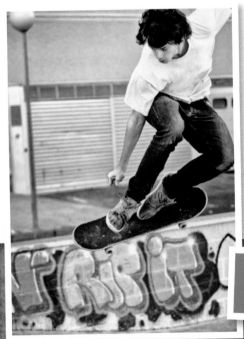

Shepard Fairey initially found inspiration in skateboarding.

able to approach the use of his street art the way an advertiser would approach the promotion of their product.

Fairey was born in South Carolina and he went to a high school that was geared towards the arts. As a kid, he had two passions: art and skateboarding. After high school, he went to the Rhode Island School of Design. He was still a student when he came up with a sticker that featured a picture of a wrestler named Andre the Giant and the word "Obey."

The simple connection between an image and a word did not have a specific meaning, according to Fairey, but the

point was to make people think about their surroundings. It really worked. The image became very famous and was a big break in his career. As an entrepreneur, it enabled him to create a clothing line called "OBEY Clothing." He also ran a printing business that made T-shirts. These businesses gave him a stream of income that allowed him to support himself as he worked on art. There was even a movie documentary that was made about him and the "Obey" sticker.

Since the sticker was a great work of advertising, he got other work for businesses

Shepard Fairey's work has been exhibited at the Smithsonian, the Los Angeles County Museum of Art, the Museum of Modern Art in New York, and the Victoria and Albert Museum in London.

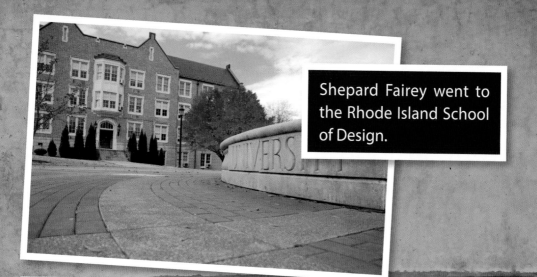

and musicians and was asked to handle their marketing. For businesses he used methods that were similar to street art to market things, such as Pepsi drinks and Hasbro toys. He also worked with the Black Eyed Peas, Led Zeppelin, Johnny Cash, Chuck D, and DJ Shadow. He even started a magazine and worked as a DJ.

At this point, you'd think he might take

a break, right? Well, his next work may be what had the most impact on the world around him. At first, his sticker campaigns were effective by just using a simple image and a word to capture people's imaginations. In 2008, in the middle of an important election, he made a poster of Barack Obama and it said "Hope."

The 2008 "Hope" poster captured people's imaginations. The Obama campaign liked it and asked Fairey to legally put it out there (i.e. not in graffiti). Fairey distributed nearly one million copies of this image in sticker or poster form. For his efforts, he received a letter

of thanks from the president! He was also named Person of the Year by *GQ Magazine* in 2008. And the U.S. National Portrait Gallery put it on display for future generations to see.

Since then he has continued to show his work at galleries in London, New York, Los Angeles, and Washington, D.C. He has also amassed a net worth of $15 million. He is not only a talented artist, but he also has a unique

Obama's campaign supported the Shepard Fairey poster.

brand. He incorporates pop culture and people respond to this.

Shepard Fairey started his original sticker campaign for fun, in order to see what his skateboarding and art school friends would think. And that opened the door for him to make a poster that was used to help elect the President of the United States. It just goes to show, there is no limit to what a good idea can bring.

Chapter 5
Street Art Versus Graffiti

When thinking about street art, one must quickly draw the line between art and damage to property. The image of graffiti on walls in a subway tunnel might come to mind. If it is not in a legal place, then it is damage to property. The street artist must carefully walk this line.

In this book, we have been interested in those who have moved from tagging walls to moving into the business world. Street art is usually in public spaces—i.e. abandoned buildings, street cars, etc. But

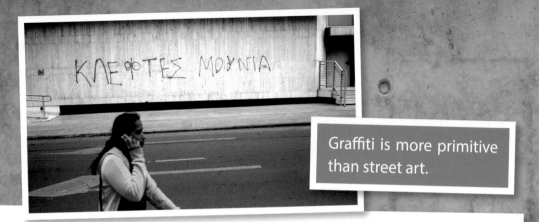

the artists in this book have made the move to galleries and museums.

These artists have made their impact by placing their art in places that are not illegal and they are gaining impact because of it. Oftentimes, cities will make certain areas available to the artist (under a bridge, on a vent structure downtown, or on the side of a building, for example) and pay them to fill these spaces. This is done so that it does not get covered with graffiti, but is instead covered with well-done street art.

One startling example of the ability to make himself stand out from the rest is Thierry Guetta. He is a bit of a legend and he is an entrepreneur that figured out ways to make money by making art. His story is told in the movie "Exit Through the Gift Shop." He is known in the street art world as Mr. Brainwash.

He was born in Paris, but moved to Los Angeles, where he ran a clothing store. He became really interested in making videos of street artists creating their work. He eventually spent so much time following other artists that he thought he'd give it a try on his own. He had made friends with such famous artists as Banksy and Shepard Fairey. The strange thing about him is that

he didn't actually create most of the art, but used a team of graphic designers to make it. He skipped the step of finding his own method and voice for art, relying on a team of trained professionals.

When he did his first gallery show, he used the team of designers to carry out the ideas he had imagined. He also used words of support from Banksy and Shepard Fairey to promote his show. This quickly established him as a top name in the street art world. Mr. Brainwash has

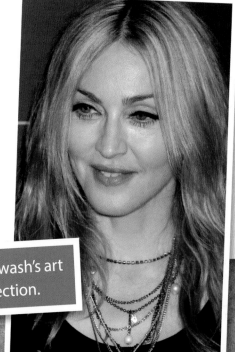

Madonna used Mr. Brainwash's art on her greatest hits collection.

Mr. Brainwash includes the statement "Life is Beautiful" on all of his artwork. All his works also include his thumbprint and signature.

made millions of dollars this way, by creating a commercial need for his art. He has done artwork in connection with Madonna and the Red Hot Chili Peppers.

Street art has made its way out of the street and into many important music projects. Hip hop videos have featured graffiti, going back to the 1980s with movies like "Beat Street," "Breakin'," and "Krush Groove." It continued to show up in music in the 1990s with the Beastie Boys video for the song "Root Down." In the 2000s, we have seen examples of

street art in projects such as Jay-Z's book *Decoded* or work by the band Coldplay, whose latest album in 2011, entitled *Mylo Xyloto*, featured street art on its cover and in the lyrics of the album.

There is a website that tracks the sightings of street art around the world. It is clear that this is a worldwide movement. It is up to the artist who thinks like an entrepreneur to find their way in this form of art that has circled the globe. It all begins with the first brush of paint!

Did you know that word-for-word, professional audio support for this book is available at Book Buddy?

GoReader™ powered by Book Buddy is pre-loaded with word-for-word audio support to build strong readers and achieve Common Core standards.

The corresponding GoReader™ for this book can be found at: http://bookbuddyaudio.com

Or send an email to: info@bookbuddyaudio.com

DATE DUE

LAKE PARK HIGH SCHOOL
ROSELLE, IL 60172